Jolicure Cats

Jolicure Cats

LORRIE BELL HAWKINS

illustrated by Dwight Kirkland

PERCHERON PRESS CANADA©

Endleaf illustration by Barbara Safran.
Cover and interior page design by Julie Scriver, Goose Lane Editions.
Printed in Canada on FSC paper.
10 9 8 7 6 5 4 3 2 1

Library and Archives Canada Cataloguing in Publication

Hawkins, Lorrie Bell, 1952-
 Jolicure cats / Lorrie Bell Hawkins.

ISBN 978-0-920187-09-8

1. Cats — New Brunswick — Biography. 2. Hawkins, Lorrie Bell, 1952-.
3. Cat owners — New Brunswick — Biography. I. Title.

SF445.5.H36 2009 636.8'0887 C2009-903594-4

Percheron Press Canada
A Division of Kristaeli Communications Inc.
PO Box 363
Moncton, New Brunswick
Canada E1C 8R9
www.percheronpresscanada.com

Dedicated to my mother and father,
Jo Anne and Lorne Bell,
the Jolicure cats —
Alice, Lucy, Sydney, Molly, Louie, Sally, Alex, Elsie,
Lily, Tigger, Fluffy, Puss, and Smudge —
and Minou.

	1969	1975	1980	1985	1990	1995	2000	2005	2009

Alice

Lucy

Sydney

Molly

Louie

Sally

Alex

Elsie

Lily

Tigger

Fluffy

Puss
(adopted)

Smudge

Minou
(adopted)

Contents

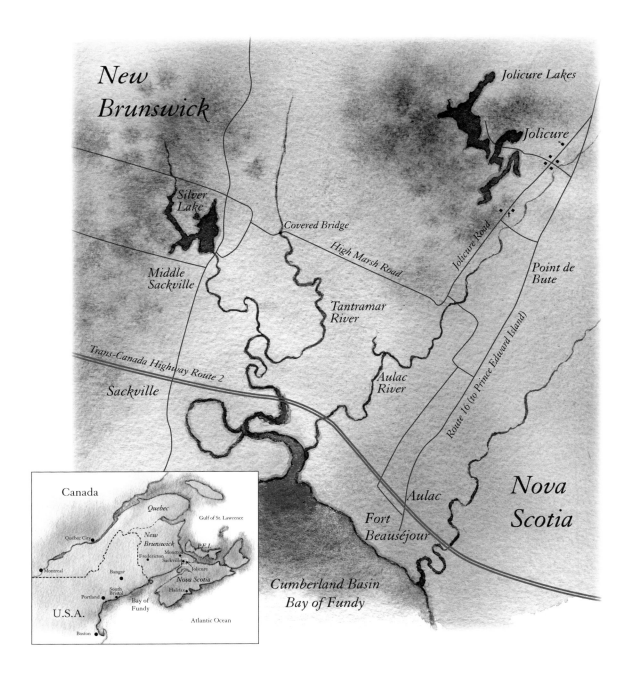

New
Brunswick

Jolicure Lakes

Silver
Lake

Jolicure

Covered Bridge

High Marsh Road

Jolicure Road

Point de
Bute

Middle
Sackville

Tantramar
River

Aulac
River

Route 16 (to Prince Edward Island)

Trans-Canada Highway Route 2

Sackville

Aulac

Nova
Scotia

Fort
Beauséjour

Cumberland Basin
Bay of Fundy

Canada

Quebec

Gulf of St. Lawrence

Québec City

New
Brunswick

P.E.I.

Fredericton Moncton
Sackville

Jolicure

Montreal

Bangor

Nova Scotia

Portland

South
Bristol

Halifax

U.S.A.

Bay of
Fundy

Atlantic Ocean

Boston

Foreword

If you were to sail up the Bay of Fundy, between the provinces of Nova Scotia and New Brunswick, to the innermost reaches of the Cumberland Basin, and then follow the meandering Aulac River about five nautical miles (ten kilometres) as the crow flies northeast until it becomes no more than a creek, you would find yourself in the small farming community of Jolicure, New Brunswick.

There was a time, not all that long ago, before the mid-seventeenth century, when the Bay of Fundy tides surged inland up the small rivers of this area with great force. At the mouth of the Aulac River, the depth of the tide could be well over thirteen metres, while about seven kilometres inland, where it intersected La Coupe River, it might still be over seven metres. At this junction, large sailing vessels were once built and repaired, while twice a day, every day, the high tides brought with them rich nutrients for the earth.

In the 1670s, some of the Acadian people, recent immigrants from France, moved to this region from Port Royal, Nova Scotia, located on the opposite side of the bay from New Brunswick. They settled on the low ridges that spread finger-like among the salt marsh rivers: the Aulac, the Missaguash, and La Planche. They named this land Tintamarre after the "hub-bub" or sound of beating wings that the multitude of waterfowl created in this wetlands paradise.

Recognizing the value of this fertile marsh, they built several *aboiteaux*: dams of earth and timber, with a wooden valve that allowed upstream water to run back out to the sea while preventing the high-tidal salt water from entering. Through their ingenuity and hard work, the Acadians reclaimed the earth and created lush agricultural dykelands from the bogs.

Under the protection of the French bastion at Fort Beauséjour, the Acadian communities of Baie Vert, Jolicoeur, Pont à Buot, and Au Lac flourished until the mid-1700s, when the strategic Chignecto Isthmus became a bloody battle-ground between the English and the French. In 1755, England conquered Fort Beauséjour, and the Acadians were brutally driven from the land they had created and nurtured. The English — mostly from Yorkshire, England — moved in.

Over time, some of the community names were "modified" to Tantramar, Jolicure, Point de Bute, and Aulac. The new settlers continued to farm the fertile fields and began to produce some of the most sought-after hay in the world. Hundreds of hay barns sprang up along the dirt roads that criss-crossed the marsh to store the loose hay before it was be shipped south of the border or overseas.

Today, the well-known gravel and mud road — the High Marsh Road — begins in Middle Sackville at Church Street, passes through a well-maintained wooden covered bridge, and crosses a portion of the marsh in a straight line for about six kilometres. It then takes a sharp turn left and follows the Jolicure Ridge (becoming Jolicure Road), until it meets Highway 16, the road to Prince Edward Island, at a junction referred to as the "crotch." One or two cared-for marsh barns still stand proudly along its route, but over the last thirty or forty years, more than a hundred others have slowly returned to the earth.

The community of Jolicure sits at the crossroads of Jolicure and Parsons roads, about three kilometres before the crotch. On one corner is the community hall,

still used for bridal and baby showers, 4-H meetings, and other local events. On the opposite is the David Oulton farm. Kitty-corner to David Oulton is the Donald Oulton farm. These lands were once farmed by their fathers, and their fathers' fathers, and are now being run by the sons. Both families claim not to be related. A schoolhouse, long used as a granary, stands on the fourth corner.

Within a kilometre or two radius of the crossroads sits the Jolicure United Church (where my husband, David, and I were married on the first day of 1979), several small freshwater lakes, and the Jolicure cemetery. The cemetery dates back to the late 1700s, and many names on the gravestones are ancestors of the people still living in the area today: Oulton, Tingley, Bowser, Chapman, Townsend, Copp, Cole. In the last hundred years, only two new headstones have been added: one for the poet John Thompson and a single stone for my parents, Jo Anne and Lorne Bell.

In the spring of 1969, when I was seventeen, my parents and I moved from the Montreal suburb of Beaconsfield to a tumbledown farm in Jolicure. I was horse-crazy, and my parents promised me that if the day ever came that we moved to a country home, they would buy me a horse. Finally in the country, I was not about to let them off the hook. By mid-July 1969, I was the proud owner of a big black Percheron-cross named Mammy.

For my mother, the move to the country meant that she could finally have a cat.

Before moving to Jolicure, we had made an annual summer pilgrimage from Montreal to my grandparents' small farm on Prince Edward Island. Besides the usual chickens and a calf or two, there were always a few kittens to play with. My mother and I secretly longed to bring one home with us, but it went without saying that my father would not tolerate a cat.

When I was eight, Marcia Peacock, my friend next door, was given a small

white-and-grey kitten that she inappropriately named Cutie. I was extremely envious of her and begged my mother for a cat.

"But you love cats," I whined when my mother adamantly said no. She was very sympathetic but reminded me that my father could not bear the creatures.

I settled for a hamster.

Meanwhile, Cutie grew into a monstrous tomcat, always ready for a fight. Marcia's hands were covered in scratches, and I began to understand my father's distaste for cats. So I decided that what I really needed was a dog.

But when we arrived in rural Jolicure, even my father could not argue with getting a barn cat. After all, there would be a few mice moving into the barn with the arrival of two cows, Mammy, and a supply of grain and hay. My father hated mice more than anything, so a working cat or two would be needed to keep the rodents out!

My parents lived on the farm for just over fifteen years. During that time, and for years after, they had many cats and kittens — smug ones, aloof ones, affectionate ones, and wild ones — cats of many colours and cats with many toes. But some stood out from the rest: the cats that earned my father's respect; the cats that were my mother's companions; the cats that won our hearts.

Their connection to one another, in some cases, was by birth. But in all cases, the cats in these stories are connected by place.

A very special place.

These are the stories of the Jolicure cats.

About the Stories

Because of the way cats multiply, the way they disappear or die, the way they come and go, it's impossible to tell one cat's story without involving another. These stories span fully forty years, from 1969 to the present, 2009. As I write, two of these cats are still living, and both my parents have passed away. I have done my best to connect the stories in a somewhat chronological order, but there is some jumping back and forth in time.

Alice, Lucy, Sydney, Molly, Louie, Sally, Alex, Elsie:
We began the summer of 1969 with three local kittens: Alice, Lucy, and Sydney. In 1970, we lost Lucy and Sydney, and we adopted two new kittens in the fall of that year. Their mothers, Black and Colours, were sisters. Black had her kittens first, and I chose a female and named her Molly. She was tiny, delicate, and jet black. From Colours's litter, I chose a grey-and-white fluffy one we named Louie.

So Louie and Molly came to the farm as cousins, and when Molly matured, she mated with Alice (yes, a male named Alice!), the remaining of the original cats. Molly and Alice produced Sally and later Elsie. Sally produced Alex. This we called the Alice legacy.

Lily, Tigger, Fluffy, Puss, Smudge:
These cats lived most of their lives elsewhere but all had Jolicure connections. Lily, Tigger, and Smudge lived with my husband, David, and me; Fluffy, with my mother and father; and finally, Puss, with my father.

Minou
Minou came to us from the SPCA. Her connection to Jolicure is through David and me.

Jolicure Cats

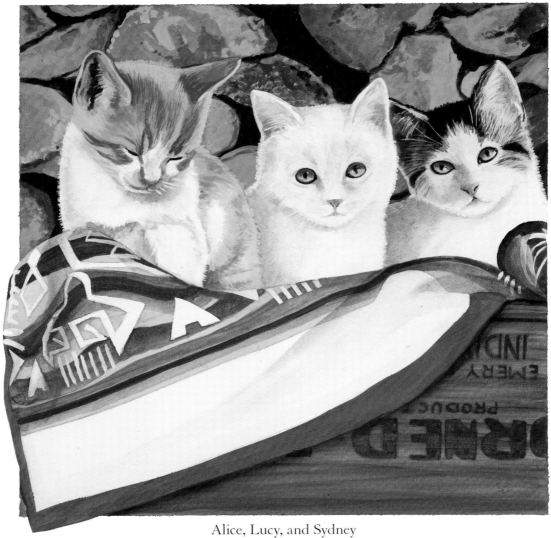

Alice, Lucy, and Sydney
We fixed up an old wooden box, lined it with straw and a soft blanket,
and then deposited it and the kittens in the shed.

Alice, Lucy, and Sydney

"Are they females?" I asked with some skepticism.

"Why sure, these is females," replied the man as he turned the small rat-like creatures over in his hand. "Yup, sure are."

"I'll take them then," I said and happily packed my new kittens in a box.

The white one will be Lucy, I thought. *And the white-and-pinkish one will be Alice.*

When I arrived home with them, my father pointed and yelled, "Straight to the barn!"

"But they're too tiny for the barn. They'll get lost, or eaten by a wild animal." My whining worked and he relented.

"Until they grow a little and then out they go."

It was the dawning of a new era. The Bell family had opened its doors to cats!

I suspect my father softened toward them right from the start, although he wouldn't admit to it. And my mother, of course, was delighted to finally have the cats she had so long been denied.

Alice and Lucy became bolder by the day and pounced on passing slippers. They scrambled up and down the lace curtains. They attacked our dog, Shandy,

a hardened cat-hater from city days. They were fearless, naughty, and ruled the house. My mother and I delighted in their antics and loved them dearly.

"I think they're ready for the woodshed," my father said one day as he removed Lucy from his pant leg. "If they are going to be barn cats, it's time they learned to live outside."

We fixed up an old wooden box, lined it with straw and a soft blanket, and then deposited it and the kittens in the shed. They immediately took to this new world of earthy smells, spiders, and dark hiding places.

In late spring, Alice and Lucy ventured outdoors. By summer, they ruled the barnyard. They were inseparable. Partners in crime. There wasn't a mouse, chicken, or a dog's tail that was safe from their tricks.

In the fall, I had my first encounter with the unfortunate destiny of most of the uncontrolled rural cat population. As I was climbing about in a hundred-year-old barn down the road looking for old tools and left-behind treasures, I came across two thin kittens huddled in the hay. As I approached, one ran away. The other, I discovered, was dead. I begged the first to come, but it remained hidden under the floorboards.

I couldn't let the kitten die. I became obsessed and spent the better part of the day coaxing it out of hiding. With a plate of food between us, we stared each other down. Finally, the starving kitten made a bold move and I pounced. I had not imagined such fury. It hissed and clawed all the way home, but I held on tight.

I let it loose in our haymow and it disappeared in an instant. We didn't see it for days but could hear its timid meowing and the food that I left was always gone. After a couple of weeks, it tolerated my presence as it ventured out from under the horse-stall floorboards. But any attempt to pet it sent it scurrying for cover.

The kitten was mostly white with a few splashes of grey tabby stripes, especially on its head, so that its sweet face appeared framed by a pixie haircut. Unsure of its gender, we decided to call this kitten Sydney. Over time it had become obvious that Alice and Lucy should have been named Albert and Lucas.

So Sydney lived in the barn, alone, longing to be loved but terrified, and Alice and Lucy, oblivious to her, ruled the barnyard and house. Then a brainwave hit. I hauled the wooden kitten box from the woodshed out to the barn, grabbed Alice, Lucy, and some food, and waited to see what would happen. Within minutes, there were three kittens at the food bowl.

They spent the following winter together in the snug kitten box in the barn. Alice and Lucy visited the house every day, but Sydney — although increasingly more affectionate — remained wary of us. In the spring when I brought the box back to the woodshed, she finally forgot her fears and joined the family.

The three kittens were now sleek young cats. Alice was a handsome white-and-orange tabby with enormous extra-toed paws. He was strong and aggressive, and king of the farm. Lucy was pure white, timid, and a bit of a loner. Sydney, with her pixie cap and luminous eyes, was sweet and loving and ever so grateful we had brought her home. When June came, we noticed the bulge in her middle and we knew her gift to us was on its way. Unfortunately, the new kittens were not to be born.

It seems I had only begun to understand cats when I was faced with a reality I had not considered. I was not so naive as to think that my animals would be with me forever, but to lose one unexpectedly, and then suddenly another, was a shock I was not prepared for.

Returning home late one night, something by the edge of our driveway caught my eye. It was little Sydney, still warm, still smiling her sweet smile. Our first

hit-and-run. It was then, with Sydney limp in my arms, that I knew every cat that came into my life would be special to me.

A few weeks later, Lucy was killed in the very same spot.

Alice continued to live at the farm for several more years. He was easygoing and good-natured and, when home, spent most of his time on an antique wooden chair in the dining room. Everybody understood that it was Alice's chair, and even guests were discouraged from sitting on it.

When Alice wasn't on his chair, he was off in the world where cats disappear to, a place their humans never know. He would be gone for days or weeks, and always return with barely a scratch. He was not the sort of tom to come home with one ear torn off or only half a tail. He would simply arrive out of the blue, meow, have a bite to eat, and curl up on his chair, the tales of his travels forever his secret.

The second to last time he disappeared, it was autumn. Weeks dragged by. Occasionally, one of us thought we'd seen him somewhere, but of course, we could never be sure. By Christmas, he had been gone for more than two months. I no longer called to him on my walks or looked for a white-and-orange cat in every farmyard I passed.

I'm not really sure if it was Christmas Day that Alice strolled over the snowbank into our yard, but I like to remember it that way. He was a little skinny and worn but seemed happy to see us as he meowed his greeting.

When Alice left again, months later, I somehow knew that this time his voyage would be an endless one. For a long time I told myself he was probably living with his "mystery" family, the family he went to when he wasn't with us, where he had his own chair and lots of love and food.

But who knows where Alice went? Or where any cat goes?

His pleasing traits got passed on to daughters, grandsons, and great-grand-

daughters. Big and thick, with mottled fur, this was the finest family of extra-toed cats for years. To this day, I can still vividly recall his presence.

But where *did* you go?

"Alice?"

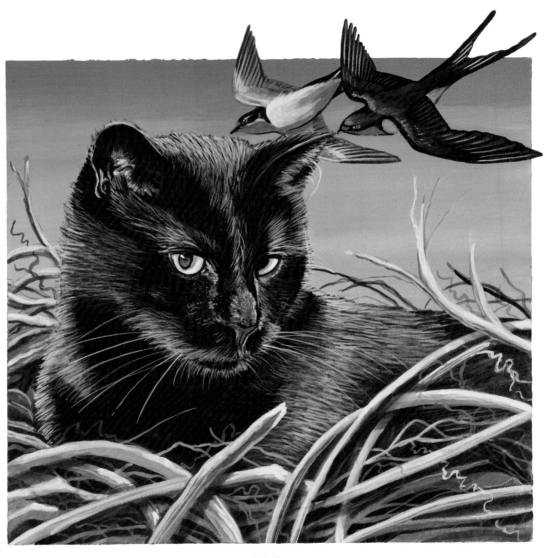

Molly

Throughout the day she napped in a nest in the porch vines or sat perched
on a tree branch and gazed at the sky for hours.

Molly

It wasn't Molly's fault that she thought she was a bird. Of course, that wasn't so obvious at first. The fact that as a kitten she spent a lot of time hanging from the dining-room curtains while other kittens roughhoused on the floor was excused by saying that she was more adventurous.

"After all," I'd say, "she's Black's kitten, and Black is as crazy as the birds!"

Maybe just by saying that, I had put that idea in Molly's head.

Molly grew into a sleek, beautiful cat. Black from the tip of her tail to the end of her nose, her agile body moved with the grace of a Siamese. She rarely played with the other cats or curled up with them. She was a loner.

In the morning, when the cats came in from their evening adventures, Molly was not with them. Five minutes later, hanging on the screen door, she would yowl to come in. As the door opened, one leap propelled her to the food bowl. One more leap to the dining-room table. Then the hall table, and so on, only touching the floor between leaps until she found her spot for the day. It was always a high spot.

Perched on the edge of an open door, on top of the fridge, in the bend of a stovepipe, on bookshelves or window ledges, she clung to her spot. When she dozed, she fell off, only to jump back up. This happened many times a day, but she would never change her place.

Like a sparrow skipping through the branches of a hedge, Molly flew about the house. Like a hummingbird she could stop in mid-air, turn in the opposite direction, land, preen, and fly into the air again.

Crazy as the birds!

Motherhood was not her forte. Once her kittens were born, she would just sit and look at them, expecting them to fly away. If one ventured too far from the nest, she did not retrieve it as other mother cats did. Instead, she chirped at it like a robin having just lost an egg in the grass.

Alice and Molly produced Sally. What Molly lacked in mothering instincts, Sally made up for. For a time, both cats had litters, but Molly invariably deserted her kittens for Sally to raise. When Sally was finally faced with thirteen kittens at once, we decided it was time to end Molly's kitten-bearing days forever.

No longer a mother, bored with hunting, uninterested in the life of a lap cat, she took to wandering or hanging out in shrubs and trees. In the mornings, she emerged sleepily from the depths of the hedge. Throughout the day, she napped in a nest in the porch vines or sat perched on a tree branch and gazed at the sky for hours.

In later years, her wanderings became more frequent, longer, and we began to worry about her.

"I think she has clouds for brains," I would say. "She'll lose her way."

Once inside the house, her affectionate side showed. Anyone watching TV became a target for her comfort. Curled up in a lap, purring and kneading, she was a picture of contentment. But quick as she came, she was off again, often forgetting to put her claws back in as she disembarked. With "threats" to her life, she would bounce off to higher ground. Only my mother really put up with her.

Molly disappeared the night she fell off the living-room window ledge.

Taking the ivy with her, she shot into the air and catapulted herself toward the front door. My father expressed a nasty expletive as he threw open the door, and a black flash vanished into the dark. Perhaps the insults were more than she could bear or maybe she missed Louie, Sally, and Alex, all gone before her, and left to find them.

Perhaps it was *her* body my father fished out of the well the following spring.

But what I like to think is that when she flew out of the house that night, she caught a rush of wind and rode it up to heaven where she so longed to soar.

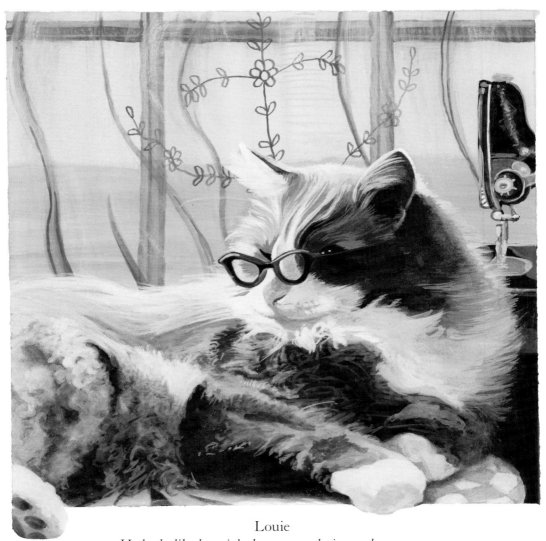

Louie
*He looks like he might be contemplating a chess move
or reflecting on the meaning of life.*

Louie

There are three theories as to how Louie got his name.

"He is named after Louis XIV, the Sun King," my mother would say.

"Louis Robichaud," my father would offer, referring to New Brunswick's first elected Acadian premier.

"No, I named him," I would answer. "Because…because…Louie just suited him!"

Louie was a throwback to some ancient genes. His mother was a shorthair tortoiseshell, and his siblings were shorthair grey tabbies, but he was a boxy mass of grey-and-white fluff, his front end indistinguishable from his back end. Choosing a kitten from his littermates, I really wanted one of the handsome tabbies. But I felt sorry for this homely one and, so, brought two kittens home.

The tabby was immediately adopted by a visiting cousin, and Louie joined our cat family. Like the "dumb blond" stereotype, his fluffiness and blank stare stuck him with the reputation of being an "airhead," which remained throughout his life. But like the ugly duckling, Louie turned into a beauty. His compressed body was replaced by a long, slender one of silky grey fur with a white bib and boots. His eyes were bright and full of expression.

"Laugh at me," his eyes said, "if it gives you pleasure. But don't think I'm not laughing back at you!"

I believe he was the most intelligent cat we ever had, but we continued to ridicule him. His apparent indifference to pain was a constant source of mockery.

"Louie is such a dope," I said one morning when he came home with several porcupine quills sticking out of his nose. He went about his grooming, seemingly oblivious to the discomfort, glancing up at us from time to time with a "so-what's-the-big-deal?" look.

He hung out with my mother as she worked, occasionally getting too near the action. He sat so close to the iron one time that all the hair down his side was singed. And once, the tip of his tail was even sewn into the hem of a skirt. He could be twisted, mauled, squeezed, or stepped on without flinching. And, unlike the other cats, he tolerated visiting children. They dressed him in doll's clothes, dragged him about the house, and never once did he scratch or struggle to get away. In fact, he was often heard purring on these occasions!

Louie appeared spineless. He could contort his body to fit boxes, baskets, paper bags, the pantry shelf, or the mitten box. He was very patient with Alex (born when Louie was two), who became his shadow, squeezing in with him at every opportunity. If there just wasn't enough room for two, a dispute invariably flared and Louie moved off, pestering everyone until he found a new place. He became particularly fond of a cast-iron frying pan that sat on top of the electric stove. Rather than disturb him, my mother often used another burner, occasionally tucking his tail back in so that it didn't burn.

"The first morning I had breakfast at the Bells," my husband, David, likes to recount, "Jo Anne went into the kitchen, flicked Louie out of the frying pan, cracked open some eggs, and proceeded to fry them in that same pan. It was less than appetizing!"

Of course, after you've lived with cats for a while, a bit of fur is nothing.

In the summer, along with the other cats, Louie spent most of his time

outside. Occasionally I'd get a glimpse of him in the long grass patiently awaiting a mouse, or I'd hear him at night, yowling and snarling at some marauding tomcat. Away from human contact, he ceased to be the pampered cat we laughed at.

However, whenever he returned to the house, he was subject again to our teasing.

"Louie left himself out in the rain again," we'd snicker as he strolled through the door, the back half of his body wet and muddy, bean leaves stuck to his head.

But what endeared Louie to me was his role in educating me in animal telepathy. Tiptoeing into a room, he would sit as close to my face as possible and stare. Leave. Come back. Leave again. I would finally follow him to the door or to his food bowl. I caught on quickly. Eventually he had my mother and me both trained so that we would simply feel his gaze from another room. In the pantry, staring at the box of cat chow, or waiting patiently by the back door, Louie's powerful stare summoned us to tend to his desires.

Louie came to the back door early one morning, leaving a trail of blood. My mother quickly scooped him in a blanket and we sped off to the vet in shock. He was hemorrhaging, possibly due to an internal injury.

So unexpectedly, so quickly, we lost Louie.

Shortly after his passing, a fuzzy, curled photograph of Louie appeared on my mother's wall of family pictures. His head is slightly in profile, his paws are neatly tucked into his chest. He has on a pair of cat-sized glasses that we acquired from an optometrist's display years before. He looks like he might be contemplating a chess move or reflecting on the meaning of life. He was most likely purring at the time. This is not a silly photograph. This was not a silly cat.

He was my mother's favourite. Her Sun King.

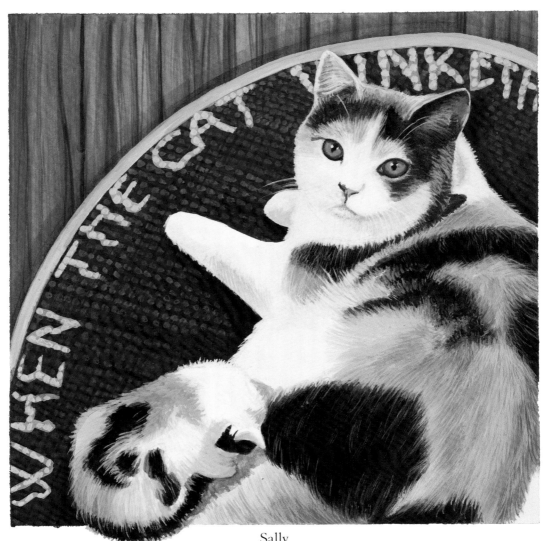

Sally
Mothering was her joy.

Sally

The coupling of Alice and Molly provided the perfect formula for calico kittens. From Molly's first set of offspring, we kept Betty, a vivid palette of white, orange, and black, and Sally, a slightly faded version of her sister.

In rural areas, distemper is one of nature's cruel ways of keeping the feral cat population under control. Unfortunately, we were not quick enough inoculating Betty and Sally, and soon they developed the symptoms. They were rushed off to the vet, but the disease was well under way and their futures looked grim. For days, my mother nursed them, pumping liquid food down their throats with an eyedropper.

Pretty Betty did not make it. Sally — small, weak, and wheezing — clung to life and survived. Can animals express gratitude? Love?

Yes, I know this is so. Sally had the benevolent eyes of an angel.

When her first kittens were born, she closed her eyes and purred as each tiny, wet kitten slipped onto the blanket. Mothering was her joy. She was not very selective and took over the care of any small animal in need of nurturing. She adopted an annoying guinea pig for a short time and effortlessly took on the task of thirteen kittens, half of which Molly had abandoned.

She asked for nothing.

Sally never clawed or hissed. She stood back from the food bowl as others dove in. She did not whine at the door to come in or go out.

She appeared to exist in a state of grace.

Finding homes for her kittens soon became a challenge, and after a while, Sally showed a hint of strain. We decided it was best for her to retire. Sadly, we made the decision too late; she was pregnant again. I believe her inner strength overshadowed her physical stamina, and somewhere along the way we had missed the weariness that now was so obvious.

My mother and I were not home when she went into her last, difficult labour.

My father found her in an upstairs closet, in extreme physical distress but purring as always. I believe he cried a good deal as he pondered what to do.

When we returned home, Sally and two kittens were already buried. We did not ask my father to explain.

How could you not love a cat with angel eyes?

Alex

In every sad story, there is a ray of happiness. Alex was Sally's ray.

A kitten from her last surviving litter, Alex was a carbon copy of his father, Alice, although not quite as handsome. He inherited his father's easygoing manner and his mother's contentment. He was a likeable cat with a pleasant, endearing personality.

When Alex was about a year old, he developed a hematoma in his ear. It was lanced and stitched. For a week he wore a gauze bandage, somewhat like a birthday hat jauntily perched on the side of his head. He enjoyed the attention and pampering he got from this experience, and although he was a healthy cat throughout his life, he clung to being needy.

With no interest in hunting, Alex liked to laze about the house comfortably snuggled in another cat's spot. Sidling up to a sleeping cat, he'd plop his big soft body down on top of the other. Molly, enraged, would flee, but Sally and Louie were more accommodating. A chair, a box, a grocery bag, all might overflow with cat. Lap duty could become weighty, and sometimes skirmishes broke out, especially if Molly was involved. Louie occasionally abandoned the spot with disdain, but more often than not he moved over and made room for his pal.

When the other cats snubbed him, Alex turned to Shandy, our aging dog. Shandy had not only come to tolerate our cats (although strays still sent him into

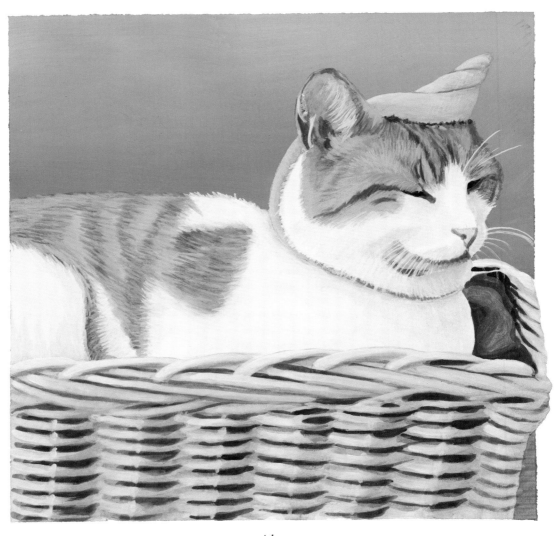

Alex

*For a week he wore a gauze bandage, somewhat like a birthday hat
jauntily perched on the side of his head.*

a frenzy), but he took a liking to Alex. They became buddies. Alex followed Shandy about the barnyard on his daily rounds and curled up beside him on the couch. The fact that Shandy was deaf, near blind, and toothless may have had an impact on this relationship, but whatever the attraction, it worked well.

Alex had been with us at least five years when he developed cancer. He was nursed by my mother until the end, when he remained faithfully purring in her lap. He was buried under the spruce trees along the property line beside his sidekicks, Shandy and Louie, gone before him.

Alex was a sweet cat, a companion cat. The cat-next-door kind of cat. I remember a little habit he had that sums up his character. Before he settled down on a cozy lap for the evening, he would gaze up and, stretching out his arm, gently touch the face above him. We called it an Alex kiss.

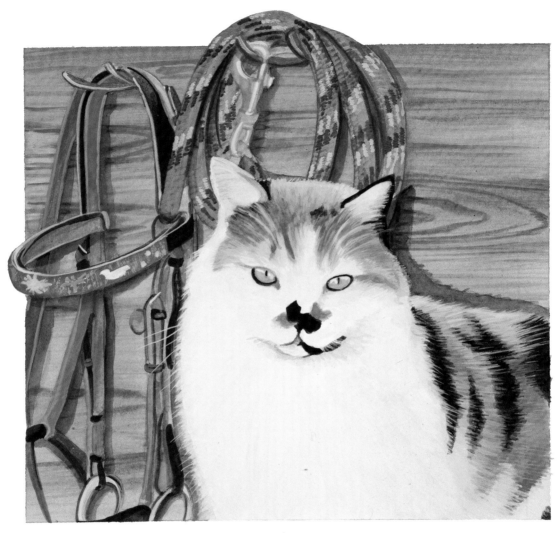

Elsie

Elsie took up residence in the barn, staying clear of the house and other cats.

Elsie

Elsie was one of Molly's last kittens. She was a gorgeous calico with a generous smattering of orange and black over her white head and body. I chose her to take with me to Fredericton, where my older sister, Holly, and I were going to study weaving at the New Brunswick Craft School and live in a farmhouse with two acquaintances. On Labour Day weekend of 1971, Holly and her tabby cat, Bilby (a Halifax cat), and Elsie and I set off in a Volkswagen bug toward an imagined communal bliss.

From day one, the experience went downhill. Elsie and Bilby were immediately banned to the barn due to one of our housemate's allergies. Instead of becoming the cat curled up on my bed, Elsie became wild and independent over the winter. When we returned to the Jolicure farm the following spring, she and Bilby were one step away from the feral cats that populated the marsh.

My sister returned to Halifax, leaving Bilby behind. He disappeared several weeks later, and Elsie took up residence in the barn, staying clear of the house and the other cats. At night when I fed my horse, Mammy, I'd lie down in the straw and wait for Elsie to appear. She'd cuddle in my folded arms and purr and knead my jacket. After many nights, she was slowly retamed.

Elsie had one unplanned litter of kittens, pretty little fluffy calico ones, that she carefully hid from us under several bales of hay. We were all kittened-out

by this time and quickly had her spayed. After the kittens and her first winter in Jolicure, she began to wander, the wild calling her back. One spring day, she slipped into the woods and was gone for months.

When a cat vanishes, a small flicker of hope burns for days that it will soon miraculously reappear. After weeks, you stop looking in ditches and begin to pray it died painlessly. Then you wait in limbo for as long as it takes for the pain to fade.

In late August, I was riding Mammy along the back hay road and spied a flash of white and orange in the bushes lining the road. I jumped off the horse in time to see a thin, raggedy calico cat take off across the field. I called out.

"Elsie!"

The cat hesitated, turned, and to my surprise came to me. In my panic to take her home, I tried to get back on the horse. She clawed her way to freedom and fled off across the field again. I broke my no-galloping-back-to-the-barn rule and gave Mammy her cue to go. We arrived just in time to see an orange-tipped tail slide under the barn door.

Elsie was back. Wherever she had gone, it was enough, and she never wandered again.

At eight years of age, Elsie finally succumbed to the comforts of the house. The sole survivor, the last of the Alice lineage, she seemed to know how important it was to my mother that she move in. By day, she was the perfect housecat, gentle and loving; at night, she retained her independence and prowled the woods and marsh, or worked mouse patrol in the barn.

Elsie lived a long time for a Jolicure cat, and grew old gracefully. Her death marked the end of an era, and the Bell farm became painfully empty.

The cats were all gone.

Lily

In 1980, after living two years in a small house on the edge of my parents' garden, David and I bought some land of our own a few hundred metres down the road and had our house moved. The question arose: Which animals would stay on the farm and which ones would come with us? The three horses we now owned stayed until we built our own small barn a year later. Our dog, Oggie, of course came. Elsie chose to stay.

On a visit to the vet, I mentioned I was looking for a white kitten with black spots. "To match the dog," I joked. Oggie, a Dalmatian and Airedale cross, had wiry white fur with black ears and one black spot on his hip.

Several days later, the veterinarian called to say, "Some kittens have been dropped for euthanasia and I have just the one for you." Eagerly, I rushed over.

The kitten she showed me was no larger than a hamster, at most a few weeks old. Its pink body was covered in white fuzz, with a faint smudge of grey on one ear. It was not the perfect kitten I had hoped for. For a brief moment I held the small animal in my hand, balancing its life and my desire to say, "No, this is not the one." But she was already in my heart.

I named her Lily.

"You become responsible, forever, for what you have tamed," says the fox in *The Little Prince*. From the days that I fed her with an eyedropper to the years

she slept under the covers by my feet, she was the first (but not the last) cat I felt an attachment to that I cannot explain.

"Why did you like that cat so much?" my husband once asked me after she was gone. "She wasn't even very nice."

Indeed, she wasn't. Paper-thin and prickly, she didn't endear herself to anyone but me. She developed the nasty habit of sharpening her claws on the furniture, the pine walls, the door frames. At first I tried to ignore the tattered sofa arms and the wood mouldings reduced to splinters, hoping they were invisible to David. But one day he looked at me and simply said, "Something has to be done. Now!"

My options were to give her away, have her put to sleep, or have her front paws declawed.

I chose to keep her.

When the bandages came off and her paws healed, I let her outside with supervision. I was surprised when she shot up a tree with the ease of a fully equipped cat. My fear for her subsided somewhat, and I let her resume an indoor-outdoor life.

One winter evening, she slipped out the kitchen door, unnoticed, into the aftermath of a snowstorm. David was unloading hay into the barn as Lily followed the tire ruts the truck left behind in the deep snow. He did not notice her white form crouching in the furrow and backed over her on his return to the house. I went outside to call her and saw her moving slowly along the tire track toward me. I knew immediately what had happened. A trickle of blood seeped from the corner of one eye, but there were no other obvious signs of injury.

After an emergency phone call to the vet, we set off with Lily over unplowed country roads and drifting highways. She stayed at the animal clinic under observation, returning several days later with no apparent harm done, her life once again spared.

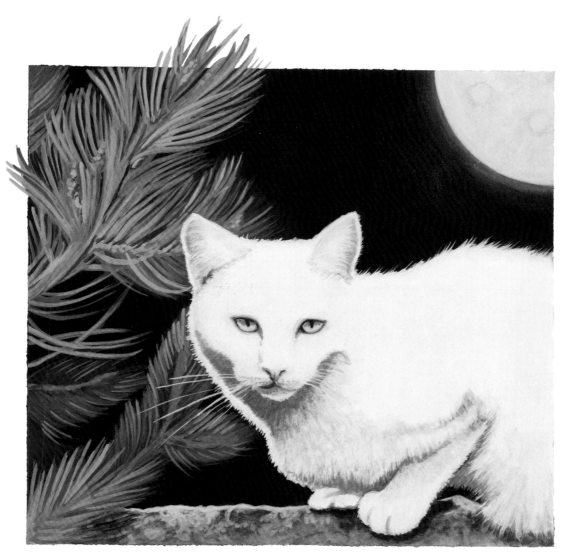

Lily
Paper-thin and prickly, she didn't endear herself to anyone but me.

In 1986, our growing business led David and me to leave Jolicure and move closer to the town of Sackville. Our new home was on a lake, surrounded by fields and woods — perfect for Lily and our other cat at the time, Tigger. But before it was ready for us, we rented a house in town for three months. I tried to keep the cats inside as long as I could, but they were constantly slipping out the door.

Fortunately they survived town life.

When we moved to the new house on Woodlane Drive, I kept them both inside until I felt they were acclimatized and then, little by little, sent them outdoors. Several weeks later while at work, I got a call from one of our neighbours on Woodlane.

"Lily is at our house. Do you want me to do anything?"

So far, there had not been a problem with her returning to our new home, and I felt confident she knew where she was. "She's okay," I said. "She'll find her way."

Later that afternoon I was struck by a horrific feeling. I quickly left work and on my way home I tried to assure myself Lily would be there waiting. I tried to tell myself I did the right thing, but a little voice kept saying, "You should have told Linda to grab her. You should have never had her declawed. You killed her."

Day after empty day, I hoped that someone had found her and taken her in. I put up posters, placed an ad in the paper, and went to every house on nearby roads. I drove to Jolicure and alerted former neighbours to keep watch for her.

I missed her for years.

That was a long time ago, but I still can't shake an intense feeling of sorrow and guilt when I think of Lily. I took away her only defence and let her down when she needed me to protect her.

I hope she has forgiven me.

Tigger

When Lily was not yet a year old, David emerged from the Volkswagen late one night with a small kitten tucked into the folds of his winter coat. He had been visiting a friend, who just happened to have some spare kittens around. It was an orange tiger with a white bib, toes, and nose. We called her Tigger.

Lily did her best to intimidate Tigger, but she had remarkable courage and a fierce independence. She gave Lily the comfort of the house and established her territory in our horse barn.

When I think of Tigger, I often think of the country song "I Overlooked an Orchid While Searching for a Rose." If Lily was my rose, Tigger was my orchid. As Lily tugged at my heartstrings, I admired Tigger's savvy outdoor skills in combat and hunting techniques. While I fretted and worried about Lily's health, I felt confident that Tigger was a survivor.

Quietly, something began to develop between me and both these cats. I remembered how Louie used to "talk" to me, and I found that I was becoming consciously in tune with Lily and even more so with Tigger. This became very clear to me when Tigger was about four years old.

I was awakened in the middle of the night during a wild windstorm, almost startled awake with the "thought" of Tigger. I rushed downstairs, pushed open

the back door against the fierce wind, and called her. Very faintly, I thought I heard one meow. Then silence. At any other time I might have thought it was just my imagination or the wind knocking the trees about, but it was clear to me that I had heard that meow and that she was calling me. We lived on a ridge between the marsh and thick spruce woods surrounded by thousands of uninhabited acres. She could have been anywhere.

I held my breath and prayed for another call. Then suddenly, without thinking, I walked out the door and into the howling wind. Somehow I knew exactly where to go. Pure instinct took me two fields over to a line of trees and rock that separated a third field, and there I found Tigger, a breath away from death, clinging to a flimsy tree branch, her neck tightly bound by a snare.

"I knew you'd come," she purred.

After we moved to Woodlane Drive and Lily disappeared, Tigger inconspicuously took her place as the number-one cat. She stayed close to home, preferring our gardens and the field between our house and the lake to wandering.

During the winter of 1993, David and I found ourselves dealing with some business and family issues that sparked an atmosphere of stress and sadness in our home. In March, we went away for a long weekend, and upon our return, it appeared that Tigger had not eaten much since we'd left. I sensed that she had picked up on my mood and had become depressed herself. After monitoring her food intake for a couple days, I was convinced she was not eating at all. Off we went to the local vet.

Tigger

*She stayed close to home, preferring our gardens and the field between
our house and the lake to wandering.*

"They do that sometimes," the vet said. "Just stop eating. I'll give her a shot of Valium. That usually kick-starts their eating desire again."

I returned home hopeful, but after a few days of no apparent change, I became very concerned. I called the Riverview Animal Hospital some fifty-five kilometres away. Five years earlier, we had taken Oggie there after several other vets had discouraged us from having two grapefruit-sized tumors removed from his chest. Dr. Sarah Moskovits had performed the surgery, and it went without a snag, adding several years to his life. I knew they could help me with Tigger.

Over the next three weeks, Tigger and I spent a lot of car time going back and forth between Sackville and Riverview. Probed, X-rayed, and tested without results, her refusal to eat remained a mystery.

"We can suggest exploratory surgery, and perhaps a feeding tube. The veterinary facilities on Prince Edward Island are equipped to deal with these situations," I was finally told. "But she's an older cat, she's lost a lot of weight… and we've done all we can."

I could read between the lines. I could put her to sleep or spend a lot of money, with possibly no happy results.

That night, I slept with Tigger in the spare room. As she lay on my chest purring, a wisp of her former self, I knew she was dying, but I also knew that neither one of us was prepared to give up yet. Two days later, I set off in a freezing rainstorm for the Island. The ferry crossing was the worst I have experienced, with the boat lunging and crashing at the thick ice still clogging the strait. On the Island side, the roads were treacherous, and I thought I must be absolutely out of my mind. But when I glanced at Tigger, calmly watching me from the cat box, I persevered. I dropped her off and returned home.

After a week of many more tests and exploratory surgery, the diagnosis was

as elusive as ever. Other than a gooey supplement force-fed to her, Tigger had not eaten in five weeks.

"The only hope is a feeding tube," said the vet, explaining the grim procedure in detail over the phone. "She is very weak," she went on, "but has a terrific attitude. She's a good candidate. Of course, we understand that most people won't go this far for a cat."

I did not hesitate to give my consent.

A week later, my mother accompanied me back to the Island to offer moral support as I learned the art of tube feeding. I swear Tigger's face lit up when she saw me. I knew that I could not let her know how frightened I was to take her home.

A bandage enveloped her whole midsection from shoulders to haunches and held in place a fifteen-centimetre-long, one-centimetre-diameter rubber hose that was sewn into her stomach. At the outer end was a plug. Three times a day, I removed the plug, syringed into the tube a well-pureed mixture of water and cat food (which I mixed in the blender when no one was looking), then flushed the tube with water. Although I had to mentally shut down each time I fed her, Tigger was totally accepting of the ordeal.

The goal was that after about two weeks, her liver would be "fooled" into functioning again. Then the other organs would kick in and she would begin to eat on her own again. Any longer and the tube could possibly cause more complications.

Because she was being nourished, Tigger began to regain some of her old shine, but after four weeks she was still not interested in food. I begged her to eat. I told her it was June and the mice were plumping up.

Then early one morning, from within a deep sleep, I heard the sound I was praying for. Crunch, crunch, crunch. I sprang out of bed. Tigger, crouching over

her bowl of kibble, looked up at me as if to say, "Okay, let's get on with it. The mice are waiting."

The cost of her ordeal, *well,* it was a lot. "For a cat?" some people might ask, raising their eyebrows in disbelief. "And you say it was because she was depressed because you were depressed? And that you read each other's minds?"

Well, I don't know much about mind reading, but what I know is that there is a space between animals and humans that Tigger and I passed through together. In that space, we were one, and I don't need to understand it to know it happened.

In June 1998, my mother passed away.

A month later, at eighteen years of age, Tigger stopped eating again.

"It's time," she said to me.

On the way to and from the vet I listened to "Con te Partirò" over and over like a song junkie. It seemed to suck up all my inner grief. I had not cried much when my mother passed away, nor at all during the memorial service for her. But now, here in the car, I was crying buckets. I thought it was just about Tigger and felt guilty for it.

Now I know it was all connected.

That day, I let them both go free.

Fluffy and Puss

A year or so after Elsie died, my mother still could not think about getting another cat. "No more cats," she told me. "I can't bear losing them."

"But isn't it better to have loved and lost than to have never loved at all?" I reminded her that these were words she often quoted to me.

On the local radio "Swap Shop" show one day, there were some free kittens advertised. I called Mom.

"Mom, there are some kittens on 'Swap Shop,'" I said. "Put your coat on, I'm taking you to get one." The kittens were in Springhill, a town about thirty kilometres from us.

It seemed a long way to go to get a cat. I knew that in our own farm community there were probably fifty kittens needing a home, but Mom had a notion that close-to-home kittens might be related to the Alice-Molly-Sally family and it would be too upsetting for her to even consider them. So we drove to Springhill, knocked on the door of a beat-up house trailer, and chose a small, shorthair, white-and-yellow-striped kitten.

"I'm going to call it Fluffy," she stated in an I-can't-live-without-a-cat-but-I-am-not-going-to-love-it sort of way.

Fluffy reminded me of Cutie, my childhood friend's ironically named kitten. Her teeth or claws were attached to your skin more often than not. She was not

Fluffy
She hung out with my mother as she sewed her toy animals.

pretty and certainly not fluffy. She ignored and even shunned my mother and only occasionally cuddled up to my father.

In 1984, my parents sold the farm and moved to a duplex in town. Fluffy survived this move and another across town to an older and more treed area several years later. She became, simply by being around for so long, the object of my parents' adoration. *A spoiled rotten cat lives here,* said a sign hanging on their front door.

Fluffy softened in her mature years. She hung out with my mother as she sewed her toy animals, and became increasingly close to my father, sitting on his lap every night as he watched TV and getting up early with him "to talk about this and that," my mother commented.

Mom continued to pretend she had no feelings for Fluffy, but I knew she really did care when, nine years after I had showed her my very first draft of these farm cats stories, she gave me two pages of handwritten copy and said, "Well, of course you'll have to add Fluffy to the book."

At age thirteen, Fluffy was diagnosed with advanced cancer and euthanized. Both my parents were deeply saddened. She was the last cat my mother had.

In the mid-1990s, my mother suffered a series of mini strokes, developed dementia, and was moved to a nearby nursing home. She had pictures of cats on her walls, the picture of Louie in his glasses on her desk, a stuffed cat that she occasionally talked to, and other cat trinkets scattered about. There was even a cat living at the home, and it wandered from room to room. But none of it was the same for her anymore.

While at the nursing home, she filled many notebooks with ramblings and thoughts, some amazingly succinct. Of Fluffy's passing, she wrote, "I am sure she is sitting at heaven's front door, waiting for Dad to join her. After four months

we still see her and feel her presence." Fluffy had been long gone when she wrote this but was still very much with her.

My father dutifully visited Mom every day, but at home he was alone. I suggested he get another cat. He looked at me and smiled but said nothing. While visiting my friend Gay (who lived on a farm in Jolicure with her husband, Thaddeus, four children, and an assortment of dogs, cats, horses — including my horse — and various other animals they had taken in), she mentioned she had a cat needing a home.

"Oh, I was thinking of getting my father a cat, but you know…" The words were hardly out of my mouth when I realized that, to Gay, this was already a done deal.

"I'll go get her. She's living in the haymow," said Gay. "She's really a house-cat, but she pees on the bed, so she has to live outside, and she's terrified of the dogs and other cats."

Puss had lived with a family as the sole object of their affection. When the woman became pregnant, the focus shifted, and when the baby was born, Puss played second fiddle. To let her feelings be known, she began to pee everywhere but in her litter box. Puss lost that battle and so Gay, who rarely turns down an animal in need, had taken her in.

A few minutes later, Gay emerged from the barn with a rotund, gorgeous, longhair calico with a ruff like a lion. She thrust her into my arms.

"She's declawed too, so there's no problem there. And I'm sure she will stop peeing if she is the centre of attention."

Before I knew it, I was in the car with Puss. My father never liked surprises, but when he saw me at the door clutching the cat, it seemed as though he was expecting us. I handed her over, along with a bag of kibble, some litter, and a cat box.

Puss
My father's loyal companion.

Puss never peed on the bed again, was content to live in a small apartment, and was my father's loyal companion until Dad passed away in 2005. After the memorial service, my father's caregiver, Alex, took Puss home to live with him. She is somewhere between the age of sixteen and twenty and, as far as I know, now lives happily with Alex's mother.

Smudge

This is the thing about Smudge.

It was a Monday morning late in August 2007. We'd moved from Sackville to Fox Creek, just outside of Moncton, and two of Gay's children were at our new house to help me move some boxes and furniture from the basement to upstairs. After we finished up, we chatted in the sunroom while waiting for their dad to pick them up. Smudge was sleeping on her chair, curled up beside the cat cushion my mother had embroidered years before.

"I think she's the only survivor," I said to the boys, meaning the last of the five kittens that had been thrown out a car window into the ditch along the Jolicure Road years ago. Theo and Julian remembered having gathered up the kittens but weren't sure how many were still alive. Two they knew of had died, but maybe two others were still alive.

Later that day, after they left, Smudge got up and came into the kitchen. I remember exactly how she sat down and scratched her chin with her right hind paw. I thought to myself, *I should have her skin looked at again. She's looking a little ragged.* She meowed at me, not for food but to go out. She was the queen of "In-Out."

"Meow. Meow." She was always a good talker too.

I picked her up, and I don't know why, but I held her to my face and looked in her eyes and said, "It's okay if you don't come back, I can't worry for you anymore. I'll be okay."

Almost a decade earlier, when I had lost Tigger, I swore I would not get another cat. Apart from not being able to face another heartbreak, our busy lives were simply easier without so many pets at home. My horse was being boarded out in Jolicure. Our dog, Scout, just like Oggie before him, went to work with us every day and was a great traveller. But several months after Tigger's death, while visiting back in Jolicure and enjoying some of Gay's homemade apple pie, she said, "We have a kitten looking for a home."

Then she told us the sad story.

Someone had driven along the Jolicure Road and over the course of about a kilometre or two had tossed out several unwanted kittens into the ditch. One of her three sons, Theo, about seven or eight at the time, just happened to hear a plaintive meow and found the first of five kittens. If there were more, they were not so lucky.

Gay had found homes for two, and her kids wanted to keep two, so there was a fifth to be given away. As I was saying, "No," David was nodding, "Yes." I shot him the "What! Are you crazy?" look, but everyone was ignoring me. Before I knew it, Gay's daughter, Inga, was in front of me with a long skinny kitten dangling from each hand. One was a beautiful grey tabby. The other was a diluted tortoiseshell.

Smudge.

For several weeks, Smudge lived in my studio. She had the freedom of the

house, but that is where she preferred to stay. From the start, we spoke. Meow talk, human talk, thought talk. It didn't matter. We understood each other.

Eventually, she moved beyond the door of the studio into the house, into the garden, and into the wild. The first winter together (and for six winters after), she travelled with us and Scout to our ski condo in the mountains of western Maine, not far from the Quebec border. At the start of the long drive, she talked non-stop, meow talk, for about an hour and then, riding on the console between the two front seats, only voiced her opinion when the opportunity arose. She often stayed in B&Bs, hotels, and motels along the way, and was always the perfect guest.

When we travelled and could not take her, Karen, who helped me with the house, took care of Smudge, coming to our home once or twice a day, letting her out if the weather was fine or keeping her company if it wasn't. Smudge had a toy basket in my studio, and whenever I returned, every single toy would be scattered throughout the house. While I was home, she never played with them.

One winter, we went away for two months. Every cat person I spoke to told me, "She'll be happier in her own home." And so that is where she stayed. The first night we were back, Smudge curled up at the foot of the bed and purred herself to sleep.

"I will wait for you forever," she said.

The trauma Smudge and her siblings had experienced as abandoned kittens left its toll on them. Of the two kittens that Gay and her family kept, Zoom, a black male, died in his sleep a year after the ordeal. Katsu, the pretty tabby I did not pick, developed a self-mutilation habit and after several years passed away. Of the two kittens that were given away, one may be still alive. Smudge, who

Smudge
"This is paradise," she meowed and disappeared into the woods.

might have been flung from the car by her tail, wore it piggy style, curled over her back. I called it her squirrel tail.

Smudge was an outdoor cat resigned to living indoors during the deep of winter. When spring came, there was no keeping her inside. We lived in a rural setting, on a lake, with hayfields and woods surrounding us. It was a cat's dream. As with my previous outdoor cats, I worried about snares, owls, foxes, poison, feral cats, and all the other horrible things that could snatch her life from me. But if she roamed, the radius was small, because she was never gone for more than twenty-four hours. I was gratefully relieved.

In the fall of 2005, we sold our country home in order to move closer to the city of Moncton. Over the winter, I packed a lifetime of stuff. The following May, we put just about everything into storage and moved to a cottage in Grand Barachois on the Northumberland Strait. Our original plan was to move back and forth between this cottage and two others we had rented on Rutherford Island in South Bristol, Maine, while our new house was under construction. We were told we would be in it by late November 2006.

I knew our lives would be disrupted and I stressed about Smudge and how she would adapt to new surroundings. I even went so far as to look for a foster home for her in the country. In the end, though, she moved with us. I had been advised by many cat people to keep her inside for a week to get her accustomed to her new setting. This was not a problem because for the first three days we were enveloped in torrential rains and no one wanted to go out anyway. Toward the end of the week, the sun came out and Smudge started getting vocal, but we were already scheduled to spend a week in our Maine cottage. Rather than confuse her, I continued to keep her inside.

So, just a few days following our first move and after seven hours in the car, we arrived for the first time at our New England "island" cottage. It was in an

idyllic setting on a point in the middle of an oak and maple forest surrounded by rocky shoreline and the Atlantic Ocean. Again, I felt I should keep Smudge in for the week. By week's end — she had now been housebound two weeks — she was howling.

Then back we went to New Brunswick.

David and I had a serious discussion in the car. It went like this.

David: "We can't live like this. She can't live like this. You have to do something."

Lorrie: "Like what, put her to sleep? (This is always my dramatic answer on animal behaviour issues.) Give her away?"

David: "Just deal with it. Please."

We pulled into Grand Barachois around eleven p.m. Smudge had meowed loudly the whole way home. We were all exhausted and distraught from the less-than-enjoyable trip home. No sooner were we inside than I opened the door again and pushed Smudge outside.

"There," I shouted. "Go!" I immediately regretted it.

The front of the cottage sat about nine metres from the water's edge, side by side by side with a string of twenty or so other cottages. Behind the cottages, parallel to the shore, ran the lane, and between the lane and the main road was a thick black spruce and tamarack woods. I went outside several times during the night and walked up and down the lane calling her name. I cried non-stop. In the morning, I got dressed and walked again, calling some more. I ran into our neighbours and could barely mouth the words, "I'm missing my cat. Have you seen her?"

In the afternoon, the posters went up on telephone poles and at the local market. That evening, we drove to Sackville along an old woods road through twenty or so kilometres of heavy forest, and I envisioned her making her way

back home through this quagmire. When we returned, I spent another night in the downstairs bedroom crying.

The next morning, David went out with Scout to look for Smudge. He says he just "felt" that Scout would find her. Minutes later, just across the lane, and kitty-corner to our cottage, Smudge emerged from a tangle of cedars, stretched, and walked over to Scout, her trademark tail curled over her back. She rubbed against him, turned, and casually walked over to David.

When David carried her through the door, it seemed as if a small miracle had occurred. But she just looked at me and said, "What's the big deal? I had to mark my territory. And by the way, what's for breakfast?"

She was never kept in again against her will. And she never skipped more than a day without coming home. But I never stopped worrying about her.

She did indeed claim her territory in Grand Barachois. And when we went back to South Bristol two weeks later, she did the same. I let her out the moment the car pulled into the driveway.

"*This* is paradise," she meowed and disappeared into the woods. Later that summer, we changed cottages in South Bristol, and I was afraid she might show up at the old one (it was just a kilometre or two down the road.) But she instantly knew this was her new home.

In October 2006, it was clear that our contractor had seriously underestimated the building schedule of our new house and a new reality set in. We would not be into our new home until spring, and the cottage we were renting was not adequately winterized. During a recent storm, the waves were practically crashing through the large picture window.

Searching for a furnished house or apartment that would allow animals became a huge stress for me. On top of that, I knew it was likely that whatever we found would not be ideal for Smudge and, again, I would have to consider

other options for her. About two weeks before we had agreed to vacate the cottage, I had lunch with a friend I hadn't seen in almost a year. I told her our plight.

"What about our cottage?" Carol said. "It's insulated, it's got a great wood stove, and you can stay there until May first!"

Well it didn't take us long to say yes. We moved in two weeks later.

Carol and Steve's cottage was closer to town by about five or six kilometres, but still along the same shoreline. What was great about it was that it was several lanes back from the ocean and far more protected. It overlooked a tidal river and salt marsh teeming with birds and wildlife, and reminded us of our old home in Jolicure on the Tantramar marsh.

Smudge was in heaven again.

The winter was fairly mild and she went out almost every day. When we travelled, there was a young couple, Francis and Monique, just down the road who delighted in taking care of her. There were two foxes — a three-legged one, and a very robust one — that passed by the edge of the property every dawn and dusk. Only once was I awakened in the early morning by Smudge calling me.

"Sorry," she cried. "But I have got myself into a bit of a pickle."

She was backed in the corner by the sun-porch, and the fox — cackling loudly — was not three metres from her. When I opened the door, she flew in, all puffed up, and then glared at the fox through the picture window. For six months, she outwitted that fox, and the eagles, the owls, and other predators of the night. For six months she was the happiest cat alive.

The following May, the house was still not finished. David, Scout, Smudge, and I moved into a tiny flat in downtown Moncton and endured four weeks of

hell. In June, we moved into our unfinished house because we just couldn't take the dislocation anymore.

At the time, Fox Creek was a brand-new golf course development. Though it was definitely suburbia, the golf course and treed lots allowed us to imagine ourselves to still be (sort of) "in the country." I knew there was no point in keeping Smudge in and released her after two days. She quickly chose the pattern of "in" during the day (when all the workmen were busy on our house and all the houses around us) and "out" at night. Early every morning she was at the front door waiting to come in.

When Gay came to visit shortly after we moved in, I remarked to her how amazing it was that Smudge always knew where her new home was. I had heard so many stories of cats that got lost or tried to return to their old homes.

"Well," she said, "the thing about Smudge is that *you* are her home. She will always return to you."

And I realized that this was true. Smudge came home for me.

Maybe when I spoke to Smudge that August day, I thought that I could handle her being gone. I was very tired from the move and ongoing construction, of constantly worrying about her, of trying to find someone new to look after her, and then leaving her at the vet's when there was no one else to care for her.

I thought I was just saying, "It's okay. I'll be okay, *if* and when you go."

But I think she misunderstood me that day and I'm afraid she heard, "Go away now and don't come back."

By the time she was gone, my heart was already breaking.

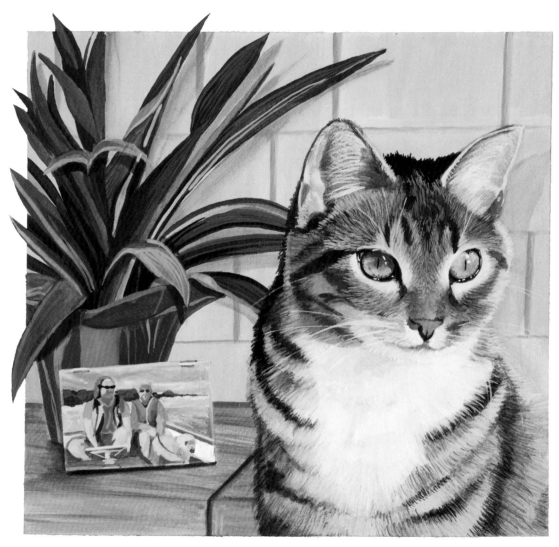

Minou
"Were our other cats this beautiful?" he asked.

Minou

A week after Smudge vanished, a week of teary phone calls, "missing cat" posters tacked up all over the neighbourhood, and daily walks up and down nearby roads, a week of hoping for any hint of what might have happened to her, I knew she was gone. Kind friends encouraged me to believe that she was merely lost, or wandering, or had hitched a ride with a construction crew to God knows where. But I knew. I knew the first morning she did not return.

I grieved for what seemed like forever.

Then one day I sat down at my computer and wrote, "This is the thing about Smudge," and realized that not only was I going to write her story, but I would also dig my old "Jolicure Cats" manuscript out from the depths of my writing files, finish this book, and in doing so, I would be okay again.

I had typed the original notes for *Jolicure Cats* — poorly — on a manual typewriter in the late 1970s and had given them to my mother, complete with my childlike colour pencil drawings of the cats. It was titled "My Mother's Nine Cats." Only a mother could have loved it so much.

Over the ensuing years I transferred my hibernating manuscript into a word-processor document, added and deleted a few cats, and then after my mother passed away in 1998, it fell back into dormancy. In January 2008, the memory of Smudge brought it back to life for me.

A lot had changed since I wrote these stories. There were several more cats I wanted to write about that were not "my mother's." I also envisioned simple portraits of each cat but knew I was not the one to do the illustrations. So I wrote, rewrote, and edited the manuscript, sent it out to a few people for a read, and began searching for an accomplished illustrator.

In August 2008, a full year after we lost Smudge, our dog, Scout, passed away. It was old age, nothing surprising, but his death left us in an animal companionship void. David and I both thought quietly about getting another pet, but together we could not discuss it. The loss of Scout and Smudge burned in our hearts, and the tears that were upon us before we could mouth the desire would not put the fire out.

The day after Smudge went missing, I had visited the local SPCA to see whether she was there. My father had been an active member of the SPCA in our early years on the farm, and as a family we had always contributed financially to the SPCA and other animal welfare agencies. But I am sad to say I had not actually been inside an SPCA in a very long time — since 1964 in fact, in Montreal, to choose a dog for my twelfth birthday. I remember being totally confused by so many dogs, cage upon cage, either doing their best to attract attention or cowering in a corner. My mother finally chose our dog, Shandy, because he was small and calm — until we got him in the car and he began to run yelping, in circles, ricocheting off the roof and the side windows. But he proved a loyal companion to our family for the rest of his life.

Brian Cormier, a cat lover and one of my readers, as well as a local SPCA board member and co-worker of David, began to alert me to specific cats that were up for adoption. Our living circumstances had changed so much I knew that if I got a cat it would have to be an indoor-only cat. And if it was an indoor cat, remembering Lily and the door frames she'd reduced to sawdust, it had

to be declawed. And though I am neither a fan of declawing cats or keeping them entirely indoors, the SPCA offered me a guilt-free choice…well, somewhat guilt-free.

Finally, a nice little tortoiseshell piqued my interest enough to go and see it, but I left without her, in tears. We just did not connect and I felt terrible that I had rejected her. As well, the overwhelming need of each and every caged animal was heartbreaking.

Then in October we lost another family member, David's sister Nancy, with whom we'd had a challenging relationship. She passed away under grim circumstances, but the one thing she and I had in common was a love of cats. She'd always had a cat of her own and made a big fuss over Tigger, then Smudge, when she came to visit. A francophone at heart, she called her cats *minou*, not kitty as I did.

On the morning after Nancy's memorial service Brian sent me an email. "New cat just in. Declawed all fours. Name Minou." Well, I don't know if it was Nancy talking to me, or Minou, but I got in my car and drove to the SPCA immediately.

I waited in the cat "playroom" for one of the volunteers to fetch her. She was released into the room — a beautifully marked black tabby with white bib and brown highlights.

"She may have been abused," said the young woman as Minou crawled into a basket and made herself look as small and invisible as she could. "I'll leave you two to get to know each other."

Reluctantly, Minou let me pick her up for a few seconds and then disappeared behind a shelf unit when I let her go. I left the room and asked if they could "hold" her for me for a day.

"That's not our policy," I was told, "but you know Brian…so maybe…"

Of course, it also helped that the director had once owned the house that David and I built in Jolicure decades before! I told them I was ninety-nine percent sure, but I just had to buy some cat supplies first. The following day, I drove through a blizzard to pick her up.

When an animal is turned in to the SPCA (as opposed to a stray,) the owner is asked to fill out an information sheet. Some do it well and some don't. I was surprised to see that Minou's previous owner had diligently filled out the form and it was very telling.

It was obvious that Minou had been loved and cared for. So why was she at the SPCA? Reason for surrendering the cat? Answer: *Moving.* But several questions later was this: Anything else you would like us to know about this cat? Answer: *May be shy at first with men, she has been avoiding my boyfriend since he started mistreating her which has forced me to give her up for her sake.*

The thread of pet abuse to person abuse is often very short, and as I read the questionnaire I could only hope that the stated reason for surrendering Minou — moving — meant that the young woman had also removed herself from an abusive situation. I have since learned that some women, in order to protect their pet, never leave an abusive situation or if they do surrender the animal, the abuser might come to the SPCA in a rage to reclaim the animal. Although the staff can protect the animal, they are helpless against the rage that may be bestowed on the abused person(s) still at home.

Minou spent her first week with us under our bed. Then slowly, every day, she became a little braver and let us in on the wonderful secret of who she is. David became smitten.

"Were our other cats this beautiful?" he asked.

I reminded him about Smudge, and Tigger, and Lily, and I would think to myself how my father first hated cats. Then the arrival of Alice, Lucy, and

Sydney, and how eventually Puss became his best companion. When you finally let a cat into your heart, there's no going back.

"I understand now, what you mean," he said a few days later, "about cats. I'm sorry I did not pay more attention to the others." In all fairness, the others were mostly outdoor cats, and we do get a lot more of Minou's time.

The guilt I feel, or perhaps more a sadness, is that she can't go outside. A leash has been suggested, but I can't risk her yeowling late at night, every night, to go out, or bolting through the door every time it's open. I tell myself it is better this way. She will not be hit by a car, poisoned, locked in someone's tool shed, or attacked by a predator. She was rescued and is now safe.

It's a compromise I can live with.

Because of Minou I have become far more conscious of the time and effort countless volunteers and organizations put toward animals in need, often with very little or no funding. The dedication of everyday people running community SPCAs and animal rescue groups, private no-kill shelters, feral cat spay/neuter/release groups, as well as individual citizens speaking out against puppy mills, farm animal abuse, and archaic animal protection laws in general, all have one message in common: ignorance and abuse toward animals, all animals, is completely unacceptable.

Afterword

The other day, while in the barn where I board my horse, one of the barn cats appeared out of nowhere and sat under a water spigot close by, staring at me. Although there was a full bucket of water beside him, this cat likes to lap from the fresh stream flowing from the tap.

"Hey you! Turn the water on. I'm thirsty," he might have said if he could. But I got his message loud and clear without a sound. I dutifully turned on the tap.

Barn cats, house cats, feral cats — all have a story to tell, a lesson or two to teach, and a heart to give. When I reread the stories of the Jolicure cats, I still cry. Like my mother in the nursing home, who could still sense the presence of Fluffy, I can still feel the joy and sorrow from the lives of each cat that came through my door.

Minou likes to sit on my desk as I write. I have to accommodate her flicking tail as she watches a squirrel at the birdfeeder and her leaps across the computer keyboard as she springs for a swooping bird outside our window. Today there is a hummingbird that is driving her wild. We are still just getting to know each other, and I can't say we have really talked yet. But little by little, day by day, we move closer into that space of *one*.

Just now she has rubbed her face against my cheek and wants to be close.

She knows I am writing about her.

Acknowledgements

The first person kind enough to review this manuscript, other than a family member, was Freeman Patterson, the renowned photographer and author. He read the badly typed original draft and wrote, "If you go into shock when you see what I am suggesting, have a drink and console yourself that my manuscripts look like this when my editor gets at them." Well, I don't remember having a drink, but I certainly saw the work I had ahead of me. However, at the same time, he also assured me that the hard part — the first draft was over. That was thirty years ago. Thank you, Freeman, for giving me both guidance and hope.

I'm not sure I can fully express my heartfelt gratitude to the many others who were so helpful in seeing this book to completion: Sandy and Wendy Burnett, Jennifer Houle, and Brian Cormier, for their numerous insightful corrections, comments, and suggestions on the text and illustrations; Veronique LeBlanc, for her technical assistance; Peter Manchester, for his finely illustrated maps; my cousin Barbara Safran for the endleaf watercolour painting; Susanne Alexander, Julie Scriver, and Akoulina Connell at Goose Lane Editions, for assistance with various aspects of the publishing of this book; Heather Sangster at Strong Finish, for editorial corrections and suggestions; Colleen Kitts, for her wise guidance in respect to publicity; and Rich Gould and Stephen Brander, for steering me to the Internet and ultimately to Dwight Kirkland and his remarkable illustrations.

And a special thank you to my husband, David, for his many edits but most importantly for believing in this project and for believing in me.

About the same time that a vision for the illustrative interpretation of these stories became clear to me I was told repeatedly by persons in the publishing world that any publisher I took my manuscript to would insist on choosing the illustrator. The illustrations are an integral part of these stories, and losing control of this very important element of the book did not sit well with me.

Percheron Press is a small publishing company David and I started to develop in the late 1970s along with several other communications companies. We decided to bring it back to life and publish *Jolicure Cats* ourselves, thereby ensuring the quality and integrity of the illustrations and other design components. I know many fine artists and illustrators personally, but the business side of publishing this book required several considerations. So I eventually found myself on a website devoted to freelance illustrators around the world and received excellent proposals from more than fifty artists. Dwight Kirkland was the first response I received, and his work resonated well with me throughout the whole process.

As we go to press, Dwight and I have yet to meet in person, but like the cats I wrote about, and the cats he illustrated, he seemed to read my mind and know what I was looking for. So thank you, Dwight; I hope you are as happy with this book as I am.

For the caregivers of our furry friends, a special thanks to: Dr. Marie Gilroy (since retired) of the Amherst Veterinary Hospital in Nova Scotia and Dr. Sarah Moskovits of the Riverview Animal Hospital — for their extraordinary kindness to me, my family, and our many pets and their staff and fellow veterinarians, past and present, who have taken care of us for more than four decades; Bill and Linda Trentini, for cat-sitting Tigger, Karen Stiles and Monique and Francis Poirier for Smudge, and Ghislaine Friesen for Minou; also to the staff and many

volunteers of the SPCA and all other animal welfare groups who take care of all animals, unconditionally, you are angels.

A special thanks to the families of Jolicure who, in 1969, accepted my parents and me into their community — in particular, David and Harriet Oulton (who I am sure to this day have cats and kittens related to our Alice) — and to our good friends Gay Hansen and Thaddeus Holownia and their children, who have provided, and continue to provide, a wonderful home for many Jolicure cats of their own.

Lastly to my father and mother — thank you, *merci infiniment,* for the cat journey that began with two tiny kittens, mistakenly named Alice and Lucy, and continues to this day with our *très belle* Minou.